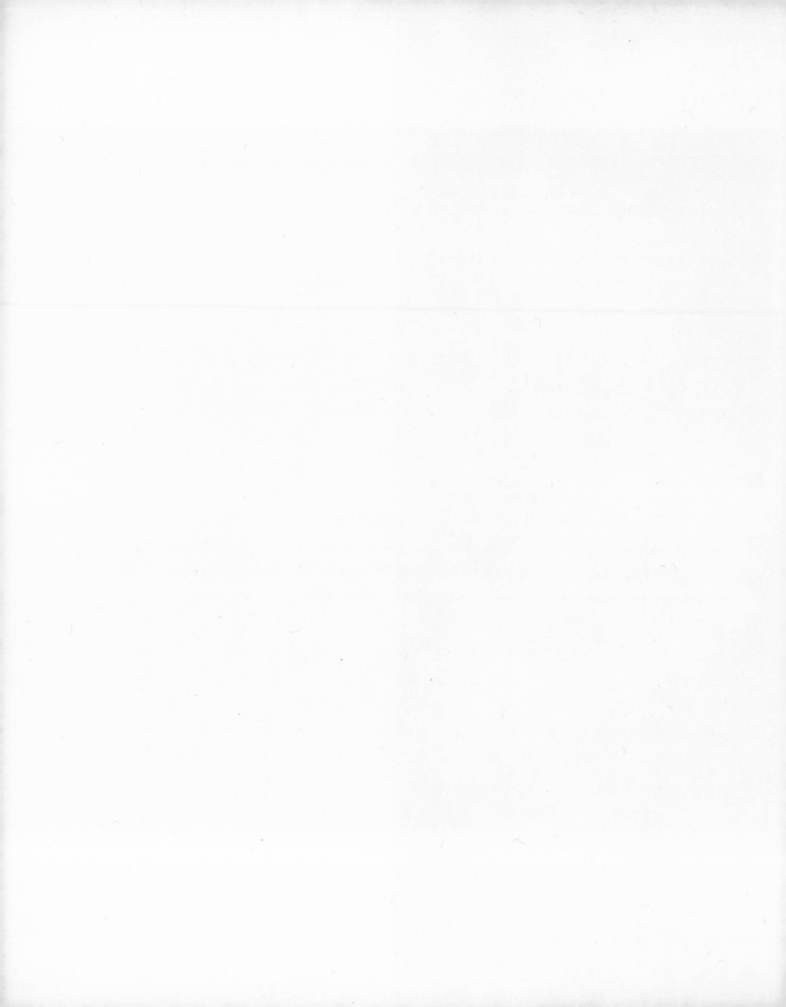

CELEBRATIONS An exhibition of original photographs
Selection and text by Minor White and Jonathan Green, preface by Gyorgy Kepes
Hayden Gallery, Massachusetts Institute of Technology, Cambridge, Massachusetts
March 1 through March 30, 1974
Sponsored by the MIT Committee on the Visual Arts
An Aperture Book, New York, 1974

Photographs by Leonard Freed, Joseph Kudelka, Wayne Miller, Mark Riboud, Dennis Stock
and Max Waldman courtesy of Magnum.
Cover photo by Gary Ruble

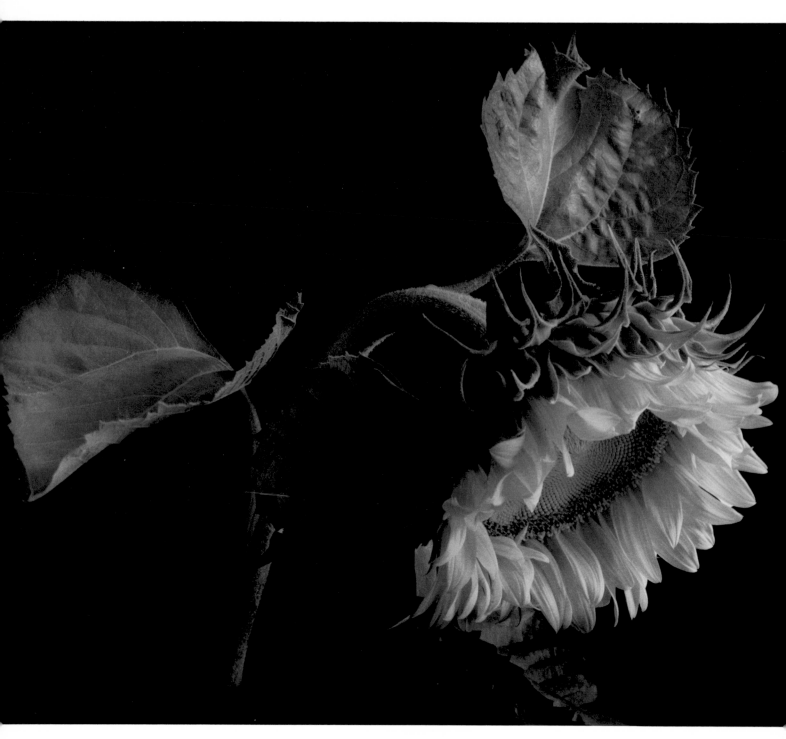

Nicholas D. Callaway

CELEBRATION, for me, means the expression of the climactic aspect of life. One celebrates when one feels fully and when one lives completely. When life has fulfillment, we respond to it with elation and with a heightened sense of being.

The highest and the richest form of the celebration of life occurs when all senses converge. I have observed children, who, by some lucky chance, have found themselves playing on an open beach. They feel their bodies and the space around them as one, simple synchronous whole. They are in ecstasy. They are victorious. They are exploding in richness.

Most of the celebrations in the past were shaped by synesthetic and kinesthetic experiences. Visual beauty, the warmth of the body, all senses and all feelings converged to create a common, rhythmical joy. Today, there is a great need for emphasizing the climactic affirmations of life's events and feelings. In our world we delegate the various parts of experience to separate sense modalities, and reproduce these fragmented experiences in thousands if not millions of copies. Man's early sense of complete focusing has been lost.

Today any experience in any media which helps bring back a sense of the richness of the world is tremendously important. For this reason, just to have a photographic image or a number of photographic images which complement each other helps the beholder to sense the bountiful spectrum of life. Everything which reminds us of the potential for jubilation is with the angels.

Recorded comments of Gyorgy Kepes

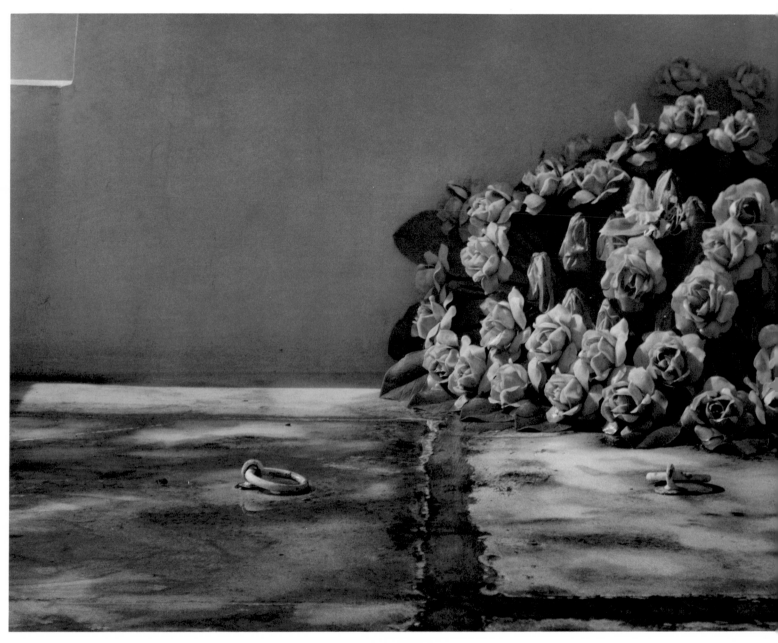

Minor White

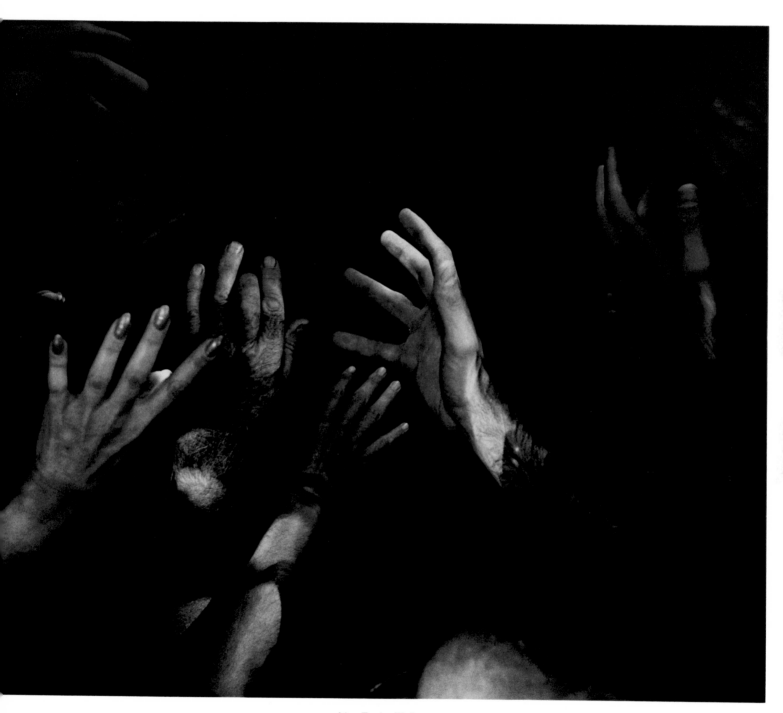

Abe Frajndlich

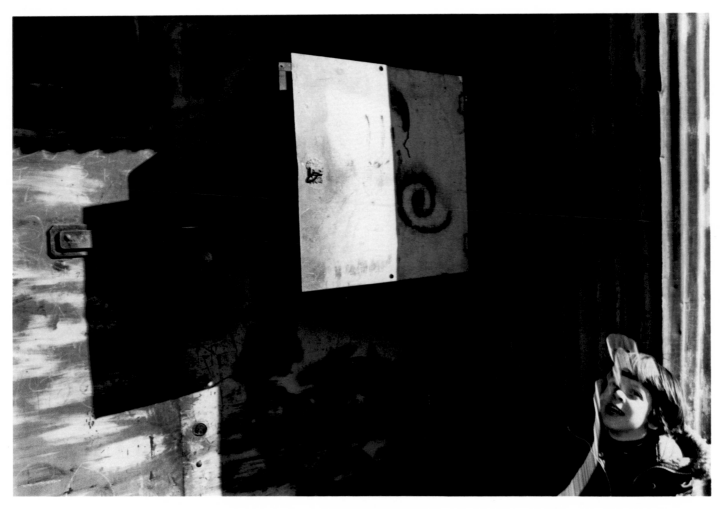

Jonathan Green

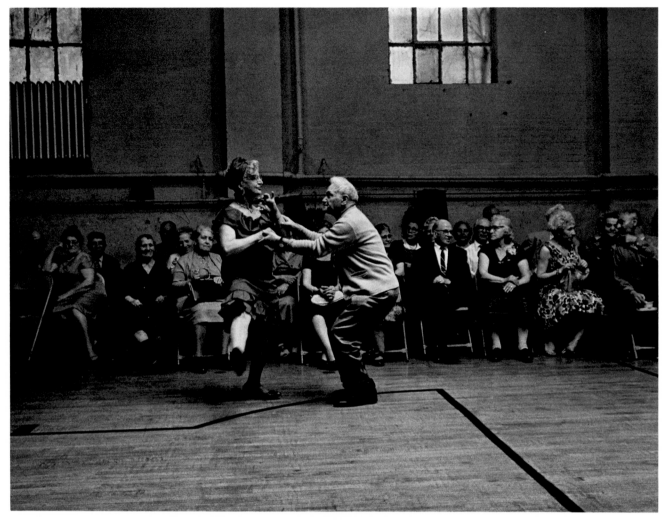

Dena

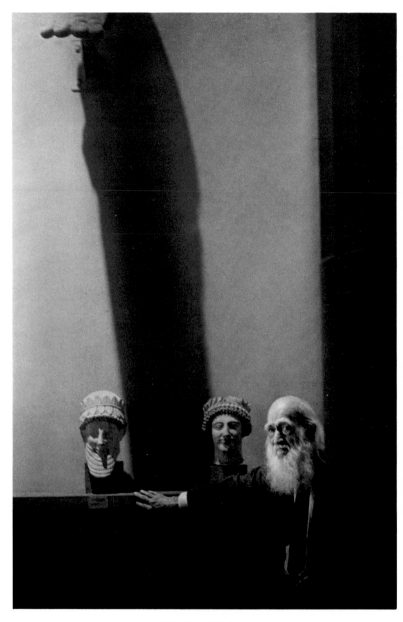

Siegfried Halus

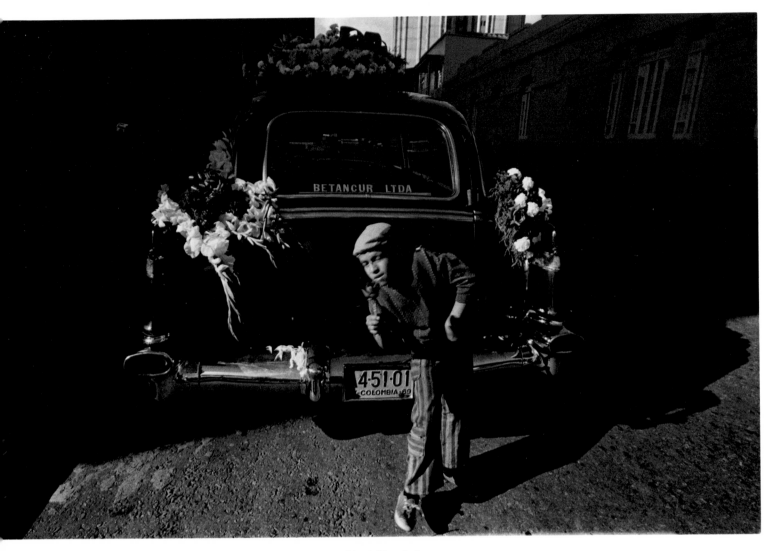

Mark Krastof

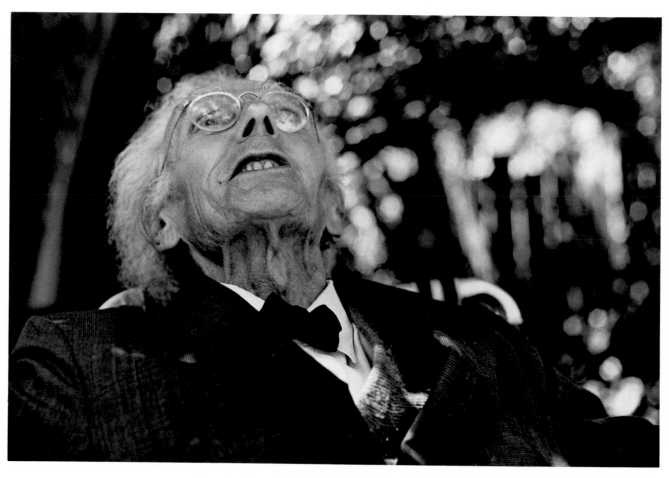

Karen S. Rantzman

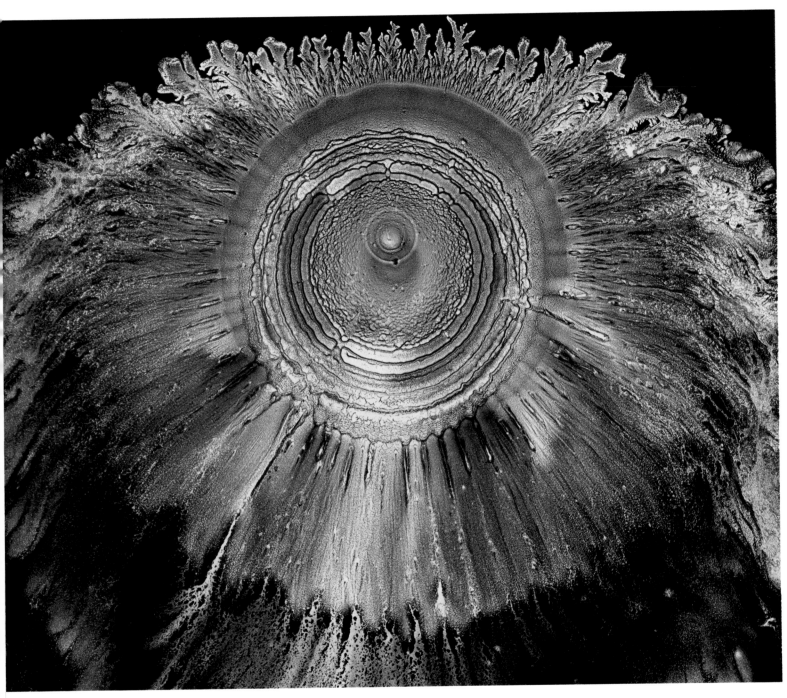

Dick Bartlett

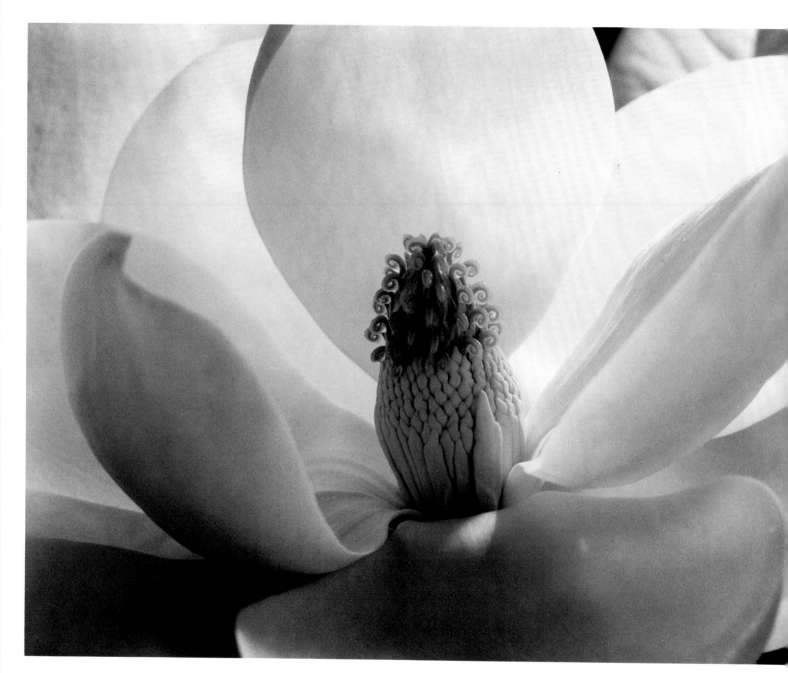

Imogen Cunningham

A PHOTOGRAPH THAT CELEBRATES IS AN AFFIRMATION OF EXISTENCE. It may celebrate life by documenting the actual celebrations of man and the commonality and continuity of human experience. It may rejoice in life through visual equivalents and expressive symbols. A photograph that celebrates may glorify the elemental forces of birth and death, sex and energy. A photograph that celebrates may exult in the imagination and the intellect, in consciousness and intuition, in the spirit and the sublime. A photograph that celebrates delights in the transition from sight to insight and extols the mystery that falls between conception and creation.

A photograph that celebrates affirms the possibility of transubstantiation. In focusing his camera on a small piece of the actual world, the photographer may find a piece of the ideal. His discovery re-enacts the fantasy leap taken by children playing with their dolls and the act of faith of communicants celebrating the sacrament of the Eucharist. Both child and communicant believe the material things of this world to have simultaneously mundane and mysterious meaning. Both seek to discover the hidden life beneath external shapes. For both, every fact of visible reality corresponds to a fact of mental or spiritual consciousness.

All art participates in this duality. In photography the continual tension between the real and ideal makes the process of transubstantiation happen right before our eyes. In Edward Weston's *Bed Pan* on page 38 for instance, we are spontaneously aware of two orders of being. The intensity of Weston's perception reveals both a utilitarian object and a sensuous sculpture, a commonplace utensil and a consecrated vessel, a recognition of the inherent elegance of a porcelain artifact and a vision of fundamental organic reality. In itself, through its own existence, an actual, sensible object has made another reality transparent. The photograph is a celebration of this discovery.

As Weston, each photographer celebrates his own Mass with his own symbols of meaning. Each photograph affirms the singularity of the creative act and the validity and specificity of individual perception. Each photograph celebrates the unity and potency of the visible world.

Jonathan Green

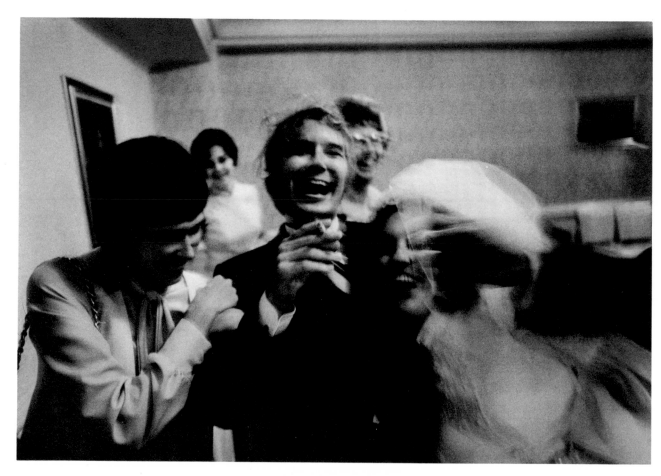

David Alan Harvey

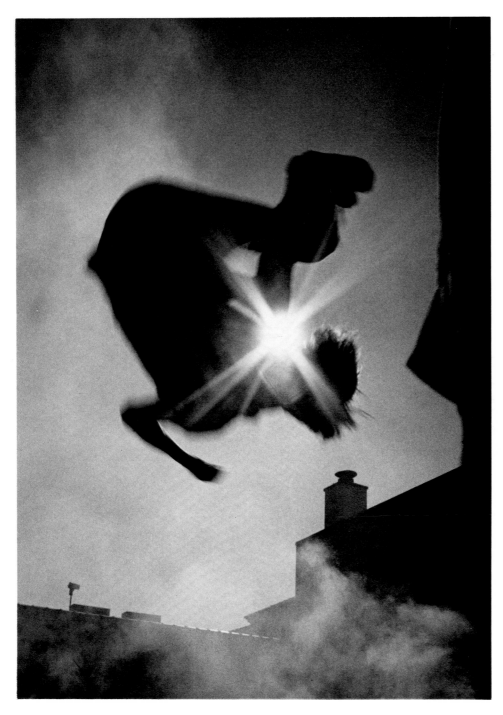

Charles Gatewood

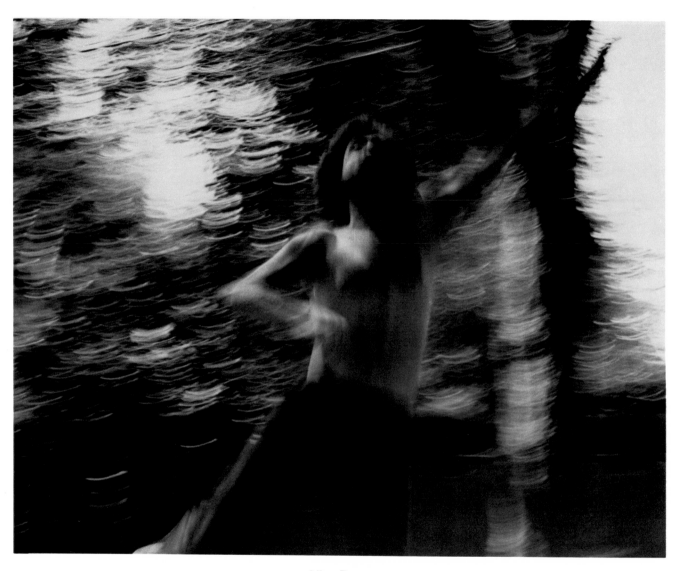

Allen Page

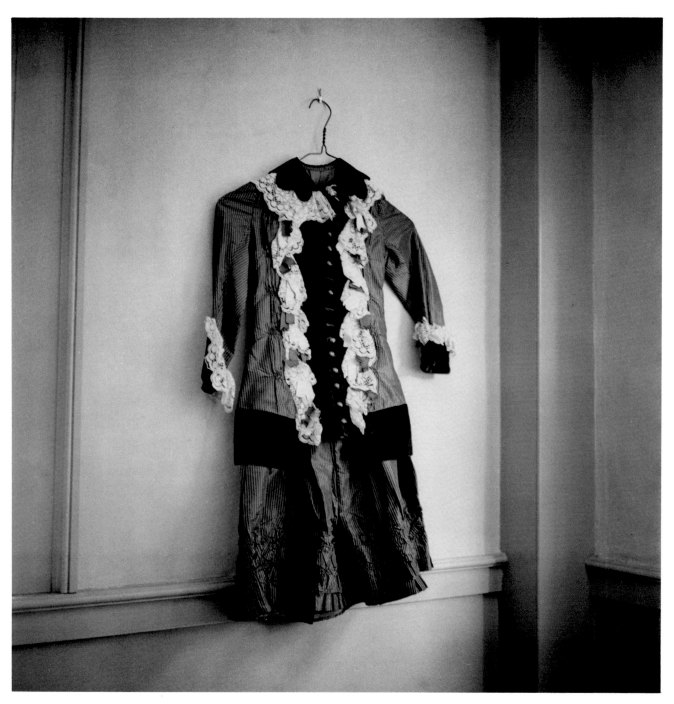

Joe DeMaio

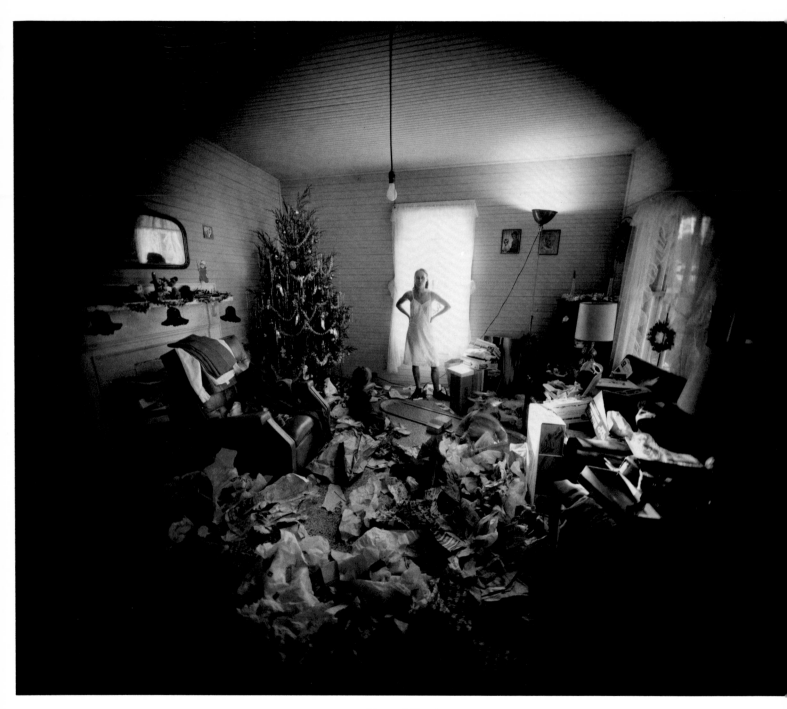

Emmet Gowin

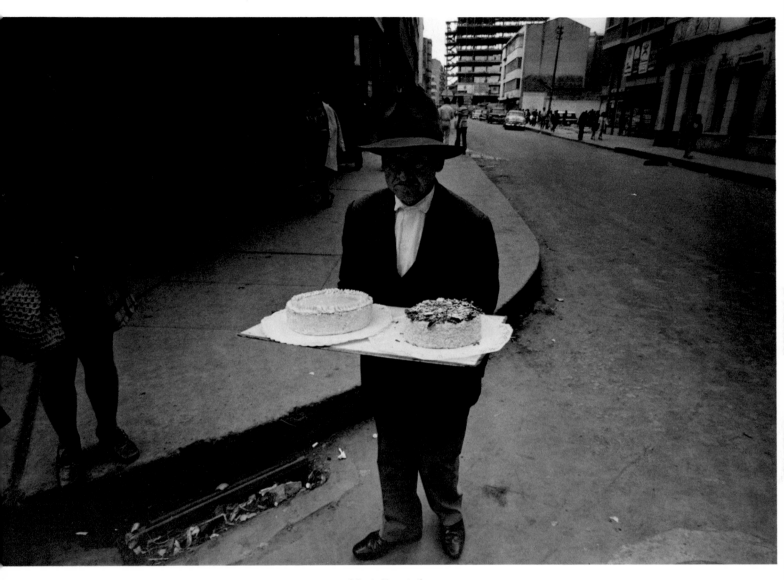

Mark Krastof

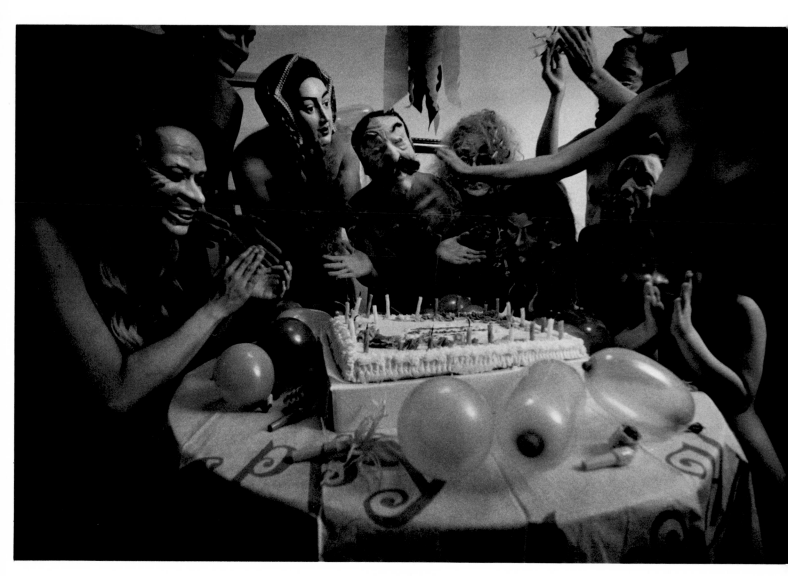

Doug Stewart

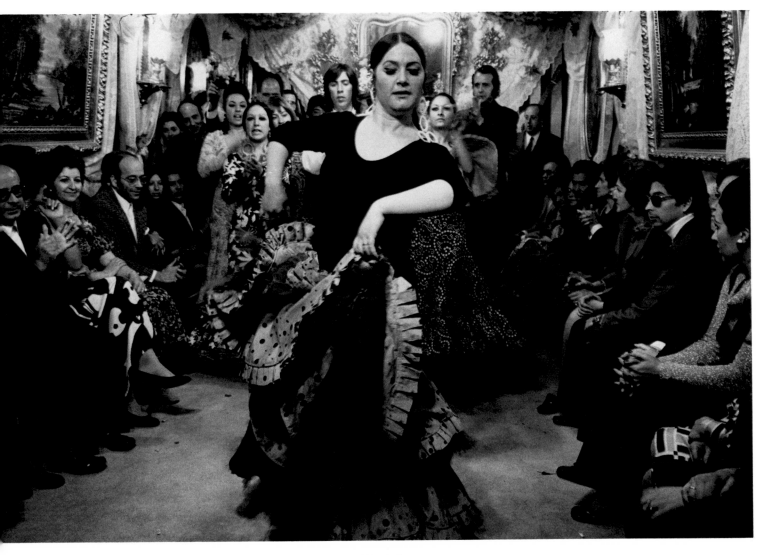

Josef Kudelka

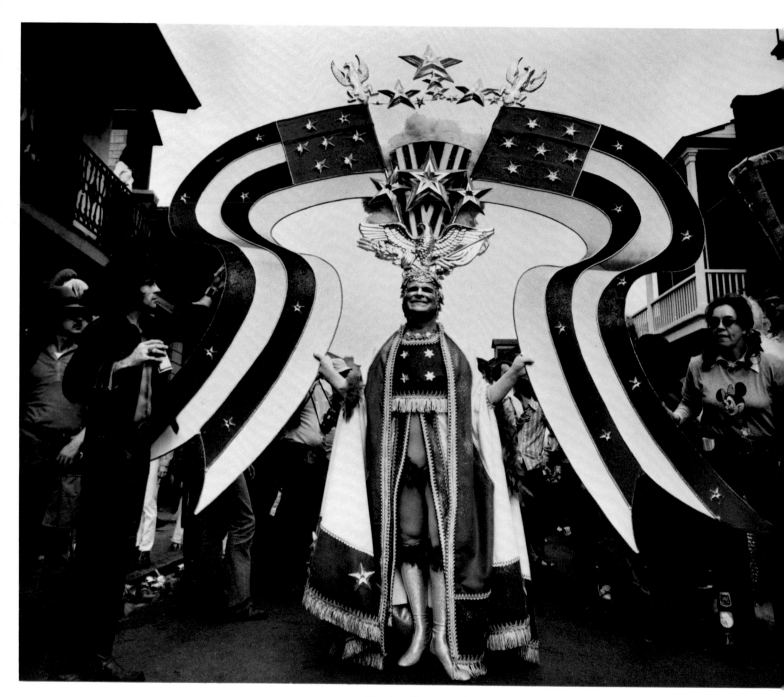

Charles Gatewood

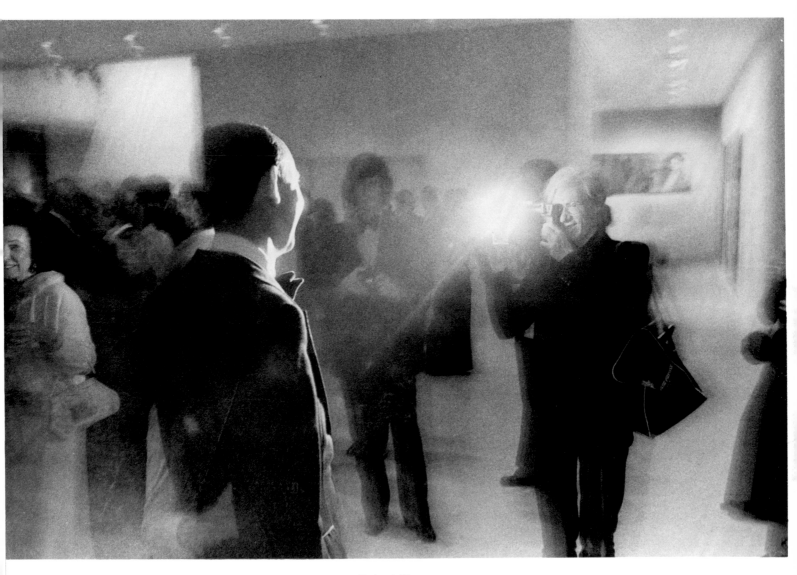

Robert Shaw

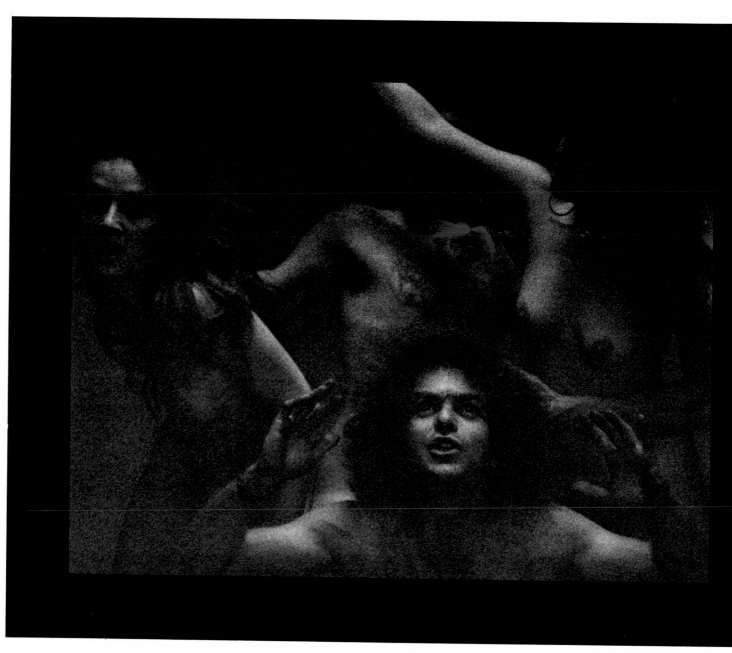

Max Waldman

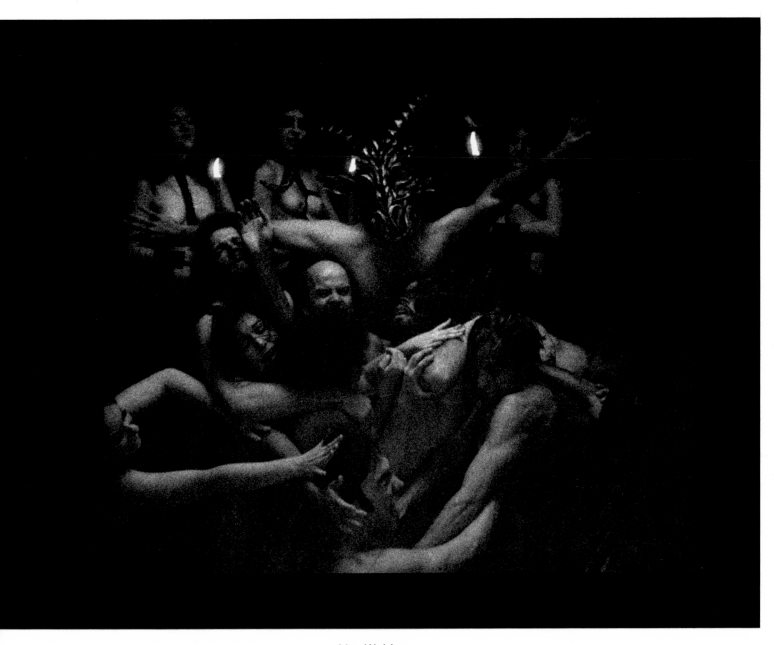

Max Waldman

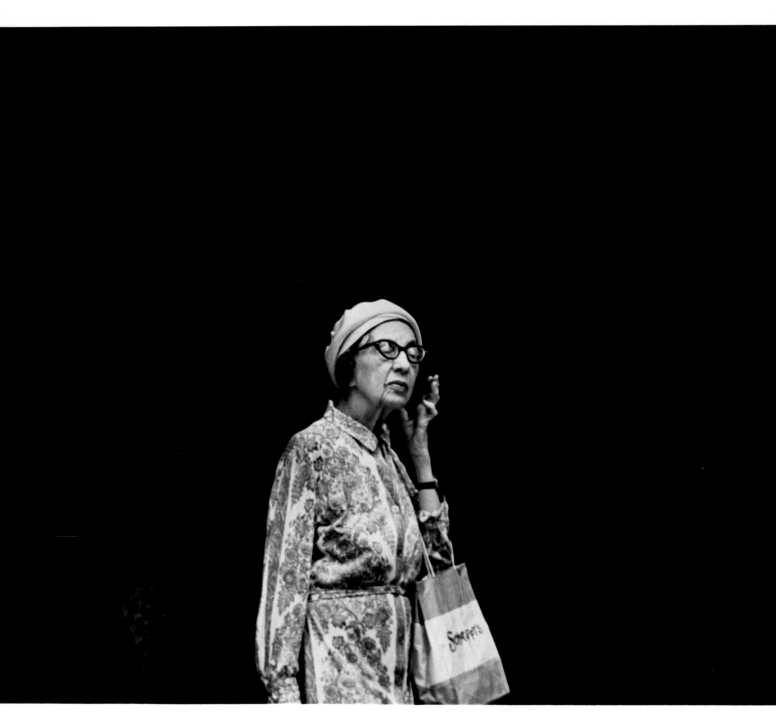

Donald Blumberg

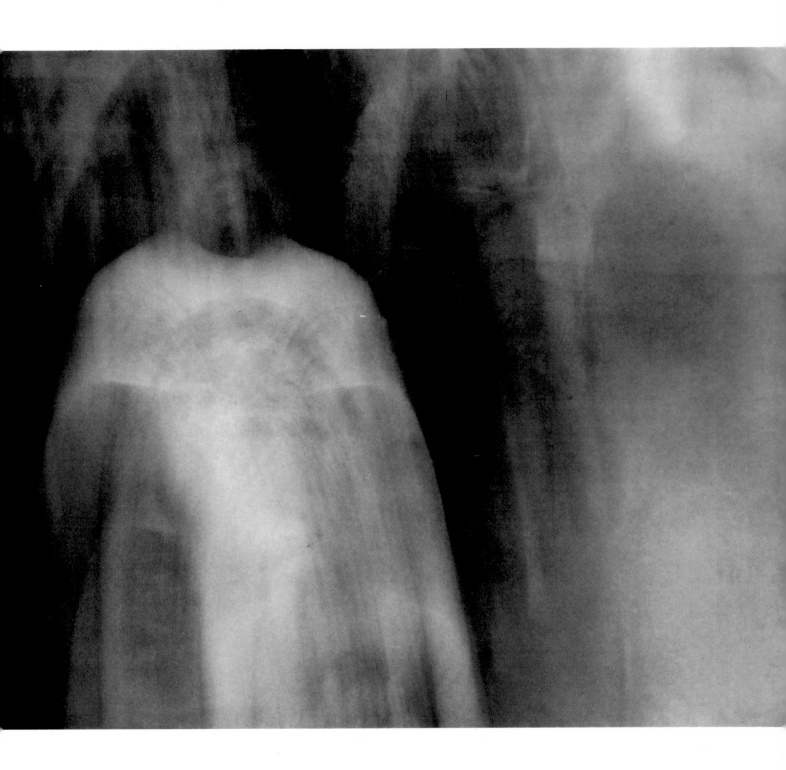

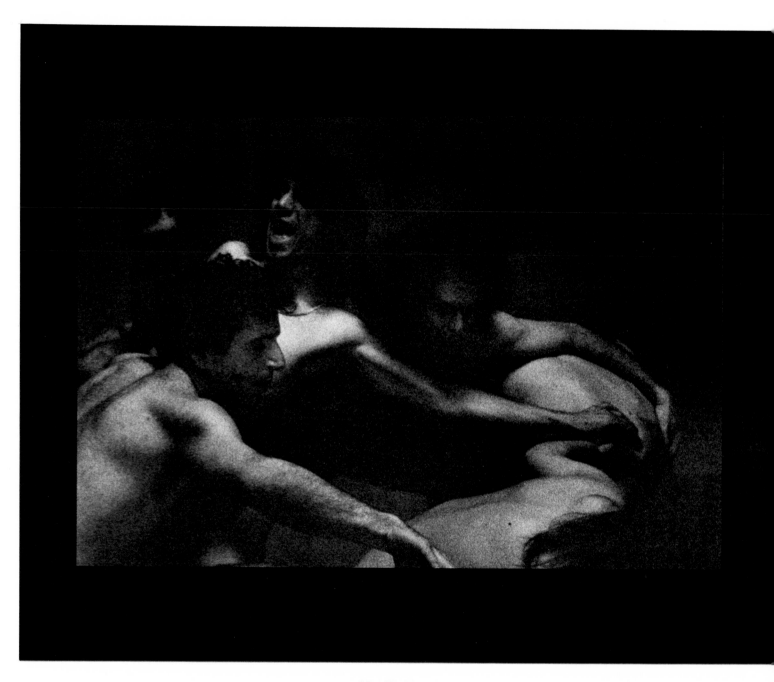

Max Waldman

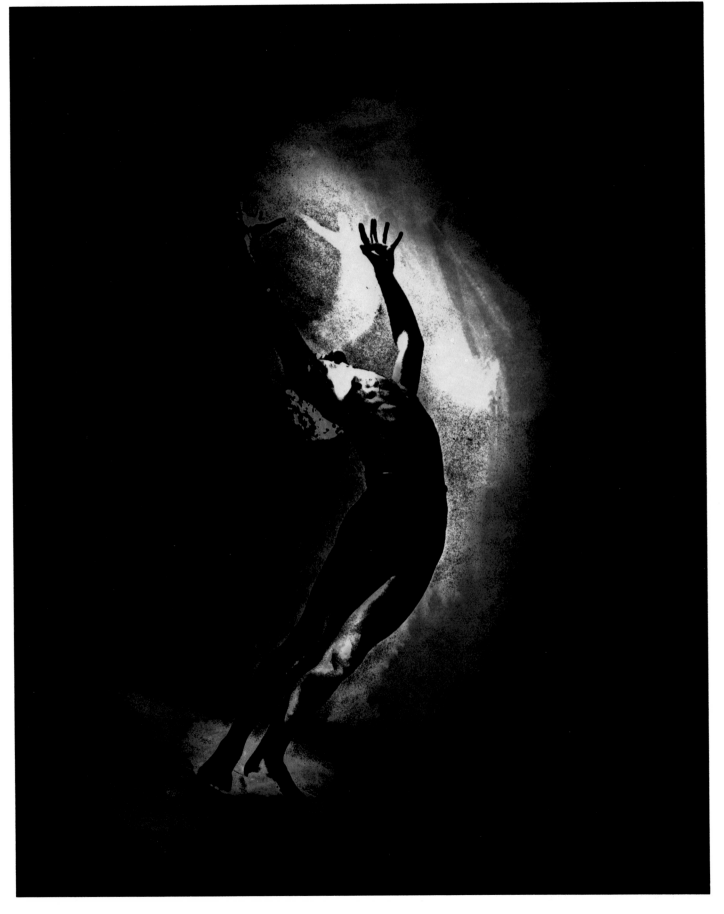

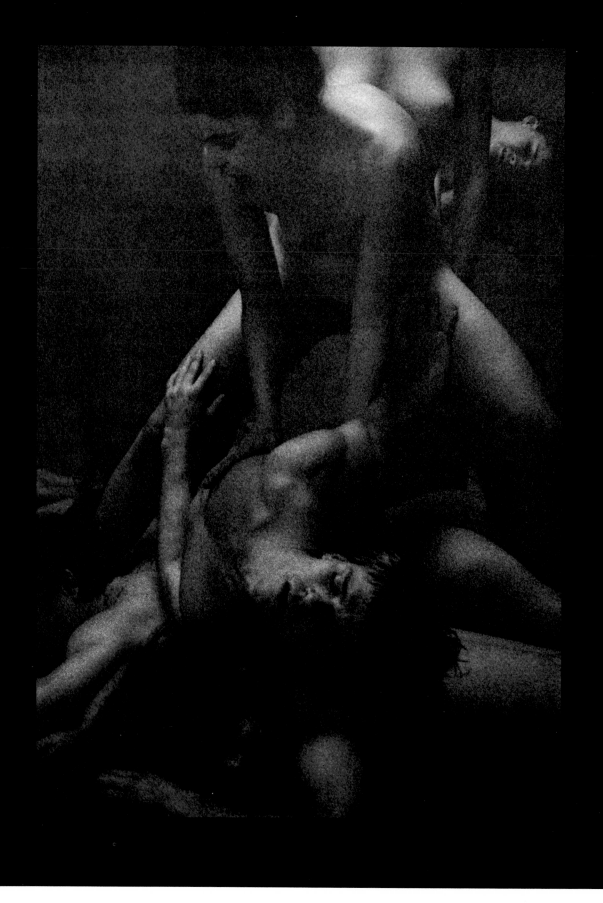

Max Waldman

THESE CELEBRATIONS BOTH SOLEMN AND JOYFUL are the cooperative work of over six hundred people. Five hundred photographers sent the editors thirty-five hundred pictures to consider. Through the courtesy of the Carl Siembab Gallery in Boston, the Witkin and Light Galleries as well as the photo library of Magnum in New York, a few hundred additional images were pored over and the best added to the show. Editing the prints was a profound experience. It was heartwarming to see so many new prints by so many new photographers. When the show finally emerged into view it was as unexpected and as stimulating as the joyful experience of watching a print come up in a tray of developer.

In our search for celebrations we looked, first of all, for the finely made print. For a fine print celebrates its subject. We sought manifestations of the reverential side of the solemn, quiet, daily celebrations and the Dionysian side of the exuberant ones. We looked for these qualities in all the modes of photography before us, documentary, pictorial, straight, experimental mixed media and snapshot. Our main regret comes from having to delete so many splendid images. Many fine photographs were unfortunately let go because a stronger one appeared, or because we found a literal image to be less communicative of feeling than its equivalent. A factual report of New Year's Eve, for example, informs the viewer's mind but may not turn on his emotions. Though many of the situations photographed were rich in meaning, photographers often failed to communicate this richness. This was the most frequent source of our disappointment ——

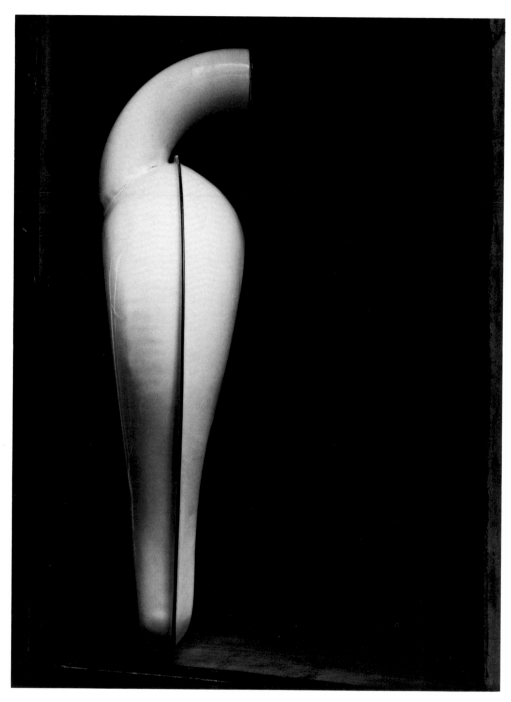

Edward Weston

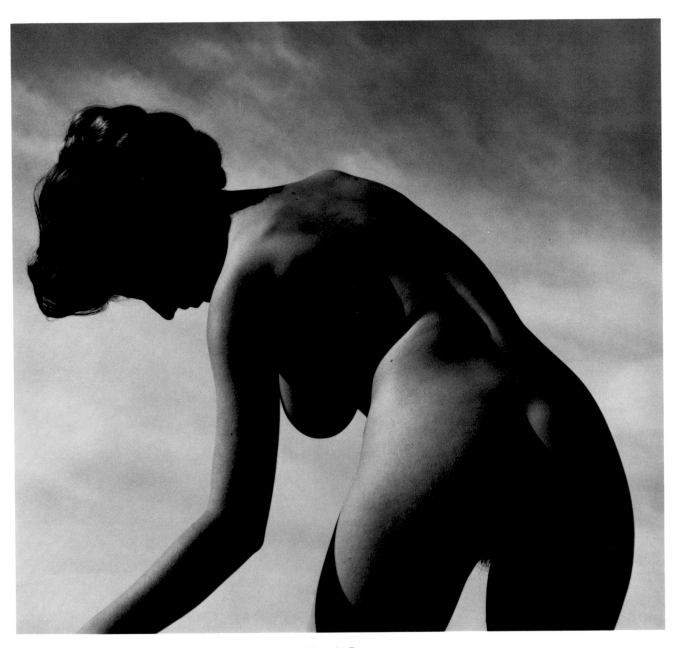

Allen A. Dutton

Gyorgy Kepes

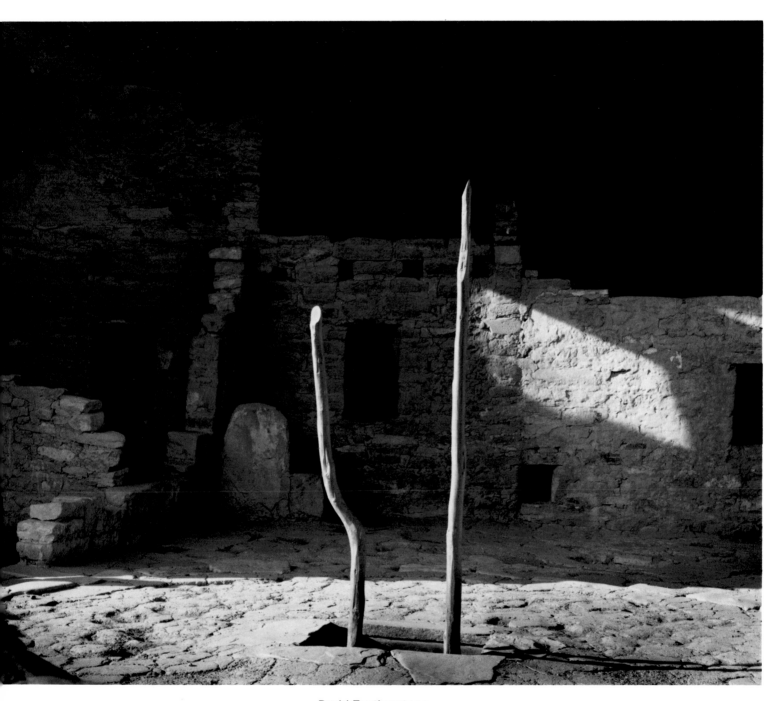

David Featherstone

NATURAL CELEBRATIONS. Except for photography, the roots of all the arts go back to the sacred. The roots of architecture, sculpture, poetry, and music originated in a time when they merged with ritual, science and the divine. Presently an American Indian shaman's ceremonial sand paintings or his dances are living relics of past celebrations when art and science were sacred and undifferentiated. The roots of the photographic media are in secular science and in a technology which is separate from art and the esoteric. They reach back only one hundred and fifty years when materialism began to dominate an already profane society.

Photographers have always wanted to be called artists. While some desired status, others hoped to gain access to the sacred which lay at the roots of art. The first quarter of the twentieth century witnessed the rediscovery of the sacred in still photography. Alfred Stieglitz in New York and Edward Weston in California each began to show how straight photography could be used to gain insight into the essential nature of things.

In the 1920's Stieglitz made a series of photographs which he entitled Equivalents. The earliest were presented as metaphors for music. Since music is the most metaphoric of all the arts, what could be more fitting? Later in his life the equivalent developed into a concept approaching metaphysical stature. Gradually he recognized the universal application of the term and extended it to all arts. He came to believe that all true things are equivalent to each other.

His naming the concept made equivalence available to all photographers. It was through Stieglitz that a creative means was opened to photography by which both the silver of the media and the specificity of the subject might be transcended.

Weston further articulated the mystique of the sacred by eloquently celebrating the organic shape of things with a joyous tactile love. Other photographers, too, found essence through their cameras. Paul Strand celebrated places, landscapes, and personality. Ansel Adams celebrated the awe and beauty of nature. In the same period Henri Cartier-Bresson and Dorothea Lange felt called upon to celebrate moments of history and social interaction. Since then the number of persons who search for and find traces of the sacred has constantly multiplied. This exhibition celebrates how many of them are under thirty years of age.

The present exhibition is the last of a series of photography shows at MIT's Hayden Gallery that began with Light[7] in 1968. No series was intended at that time, but there was no mistaking its inevitable progression. Light[7] celebrated the equivalent role of light in photographing the sacred. Be-ing Without Clothes, which followed, celebrated the human body and the theme: neither nude nor naked, but divine. The third show, Octave of Prayer, attempted to look for the place of photography in the esoteric ritual. Celebrations, while pointing up the interrelatedness of the three previous themes, perhaps suggests something of the potential unification of art, science and the sacred. Probably many generations lie ahead before the photographic media recapitulate the deep-set roots of the older arts ——

PHOTOGRAPHERS CAN ONLY TAKE PICTURES OF LIFE IN THIS LIFE and if they strive to manifest unseen forces, either inner or outer, they must resort to the roundabout way of equivalence. Picture editors in this life can only arrange photographs. Equivalence is the option they turn to when they seek to cope with the hidden. Their sequences are analogous to the photograph and so may be used to reveal the potential of equivalence. In Celebrations the sequences could just possibly function as equivalents of growth and development on the dark side of the grand cycle of death after life and life after death.

Minor White

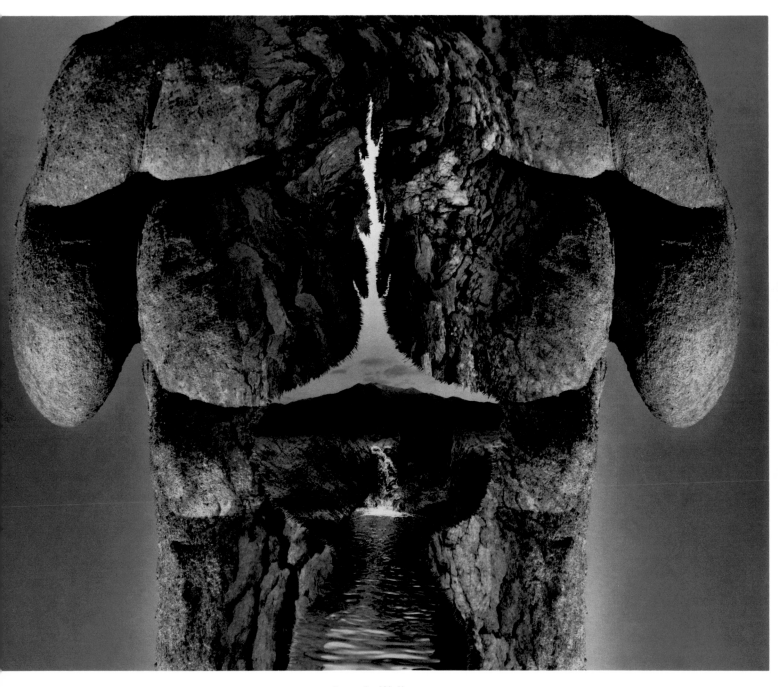

Larry L. Wallace

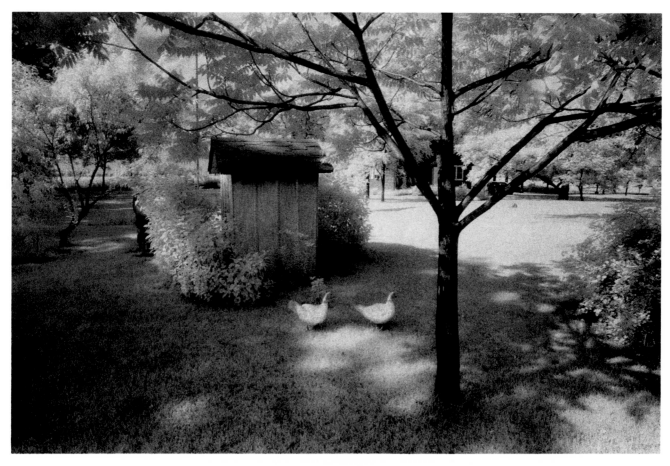

Terry Reed

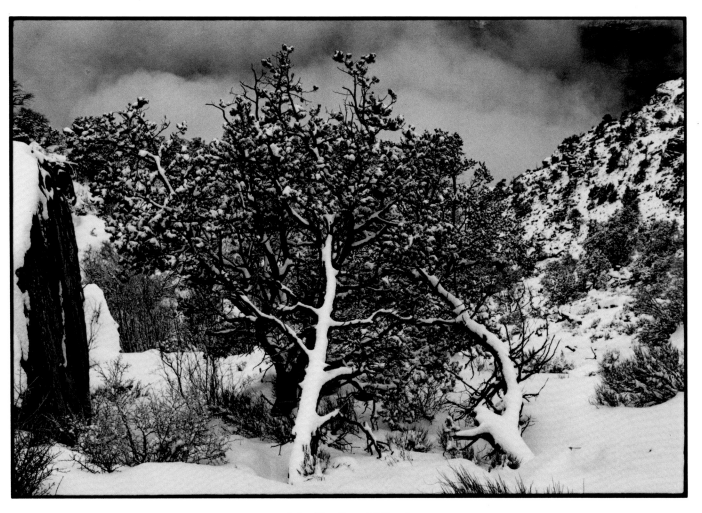

John MacDonald Snyder

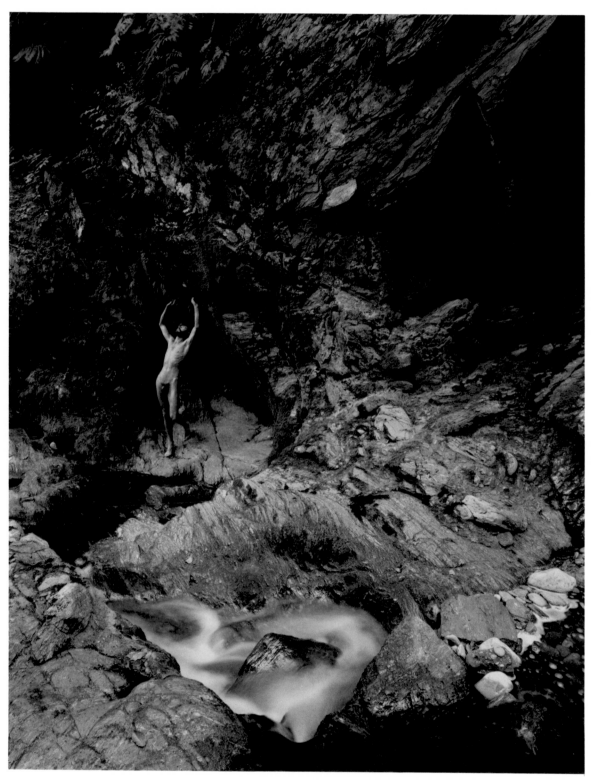

James Newberry

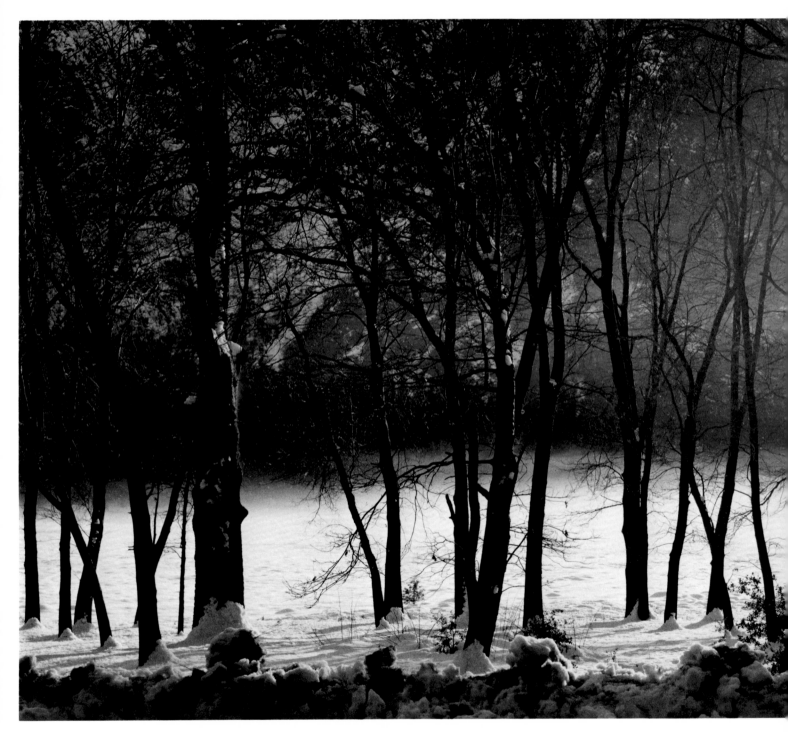

Lawrence Anderson

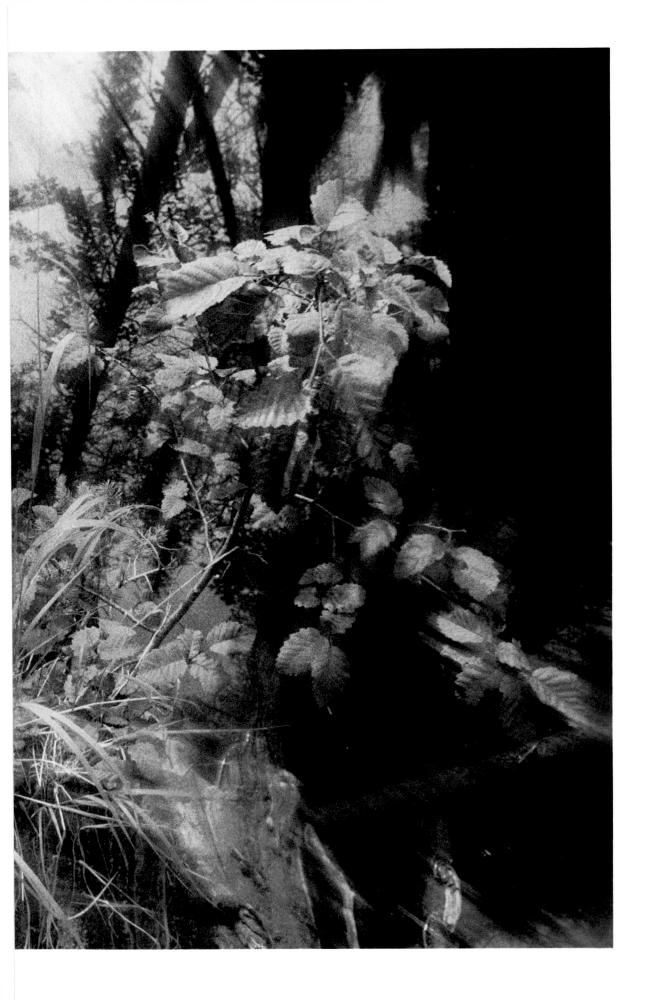

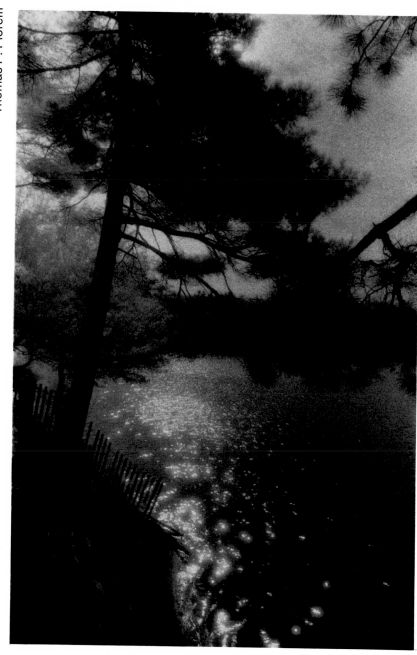

Thomas P. Fiorelli

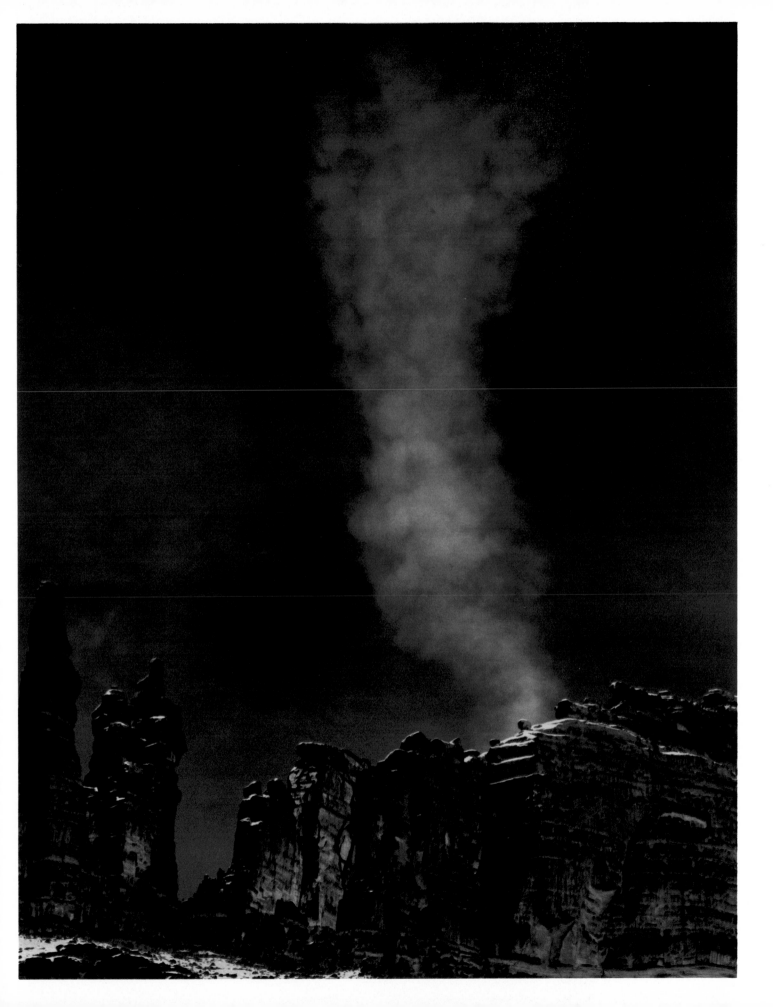

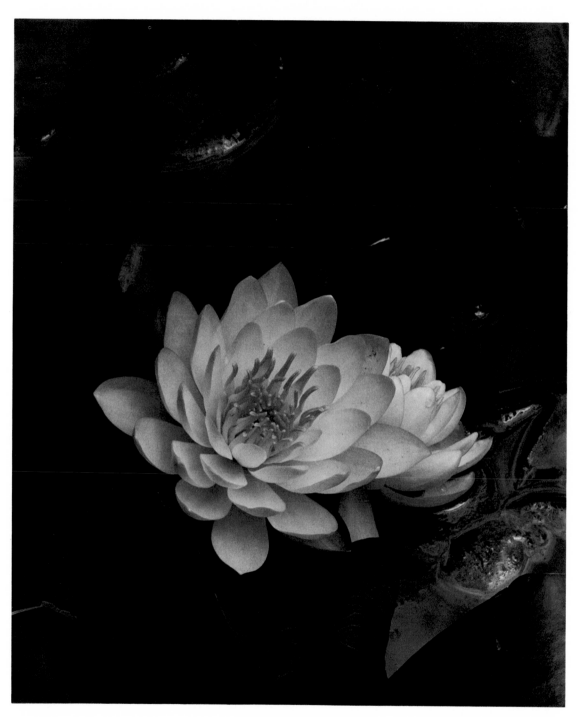

Caroline Vaughan

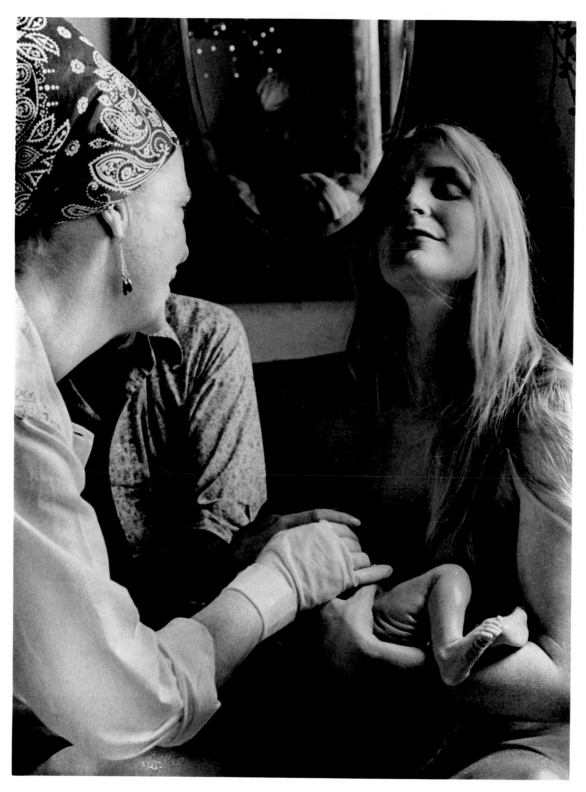

Jacqueline Poitier

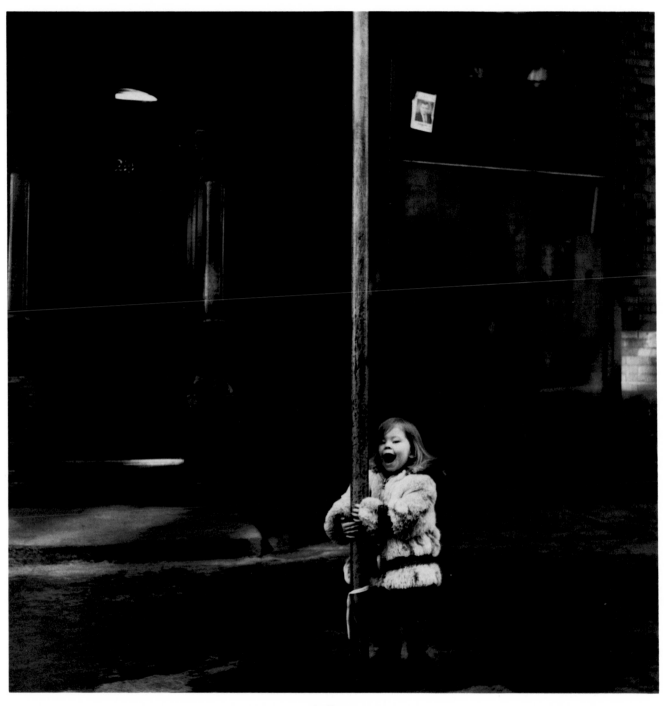

A. Doren

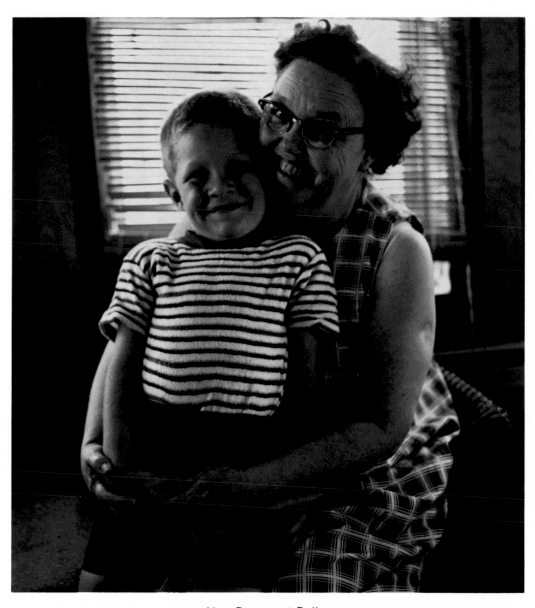

Alma Davenport Dailey

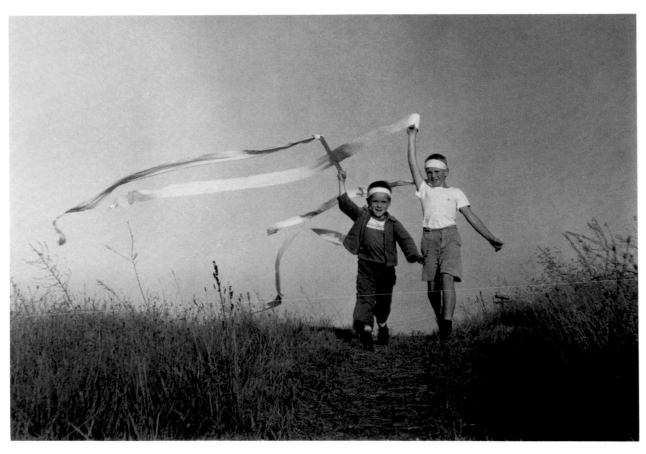

Wayne Miller

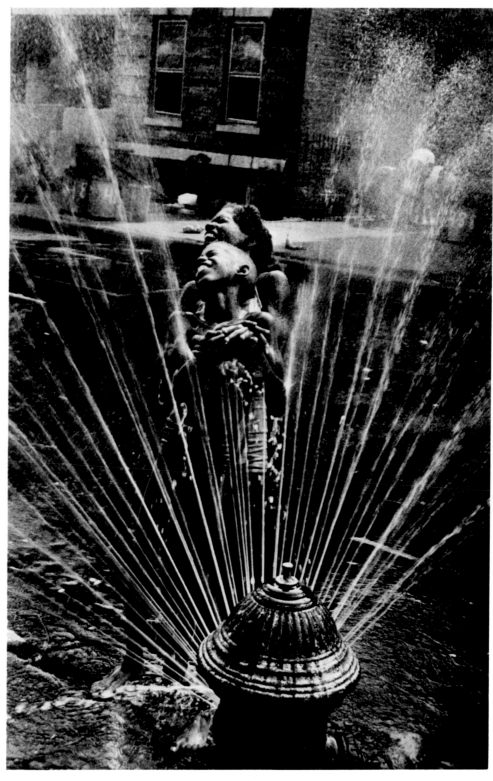

Leonard Freed

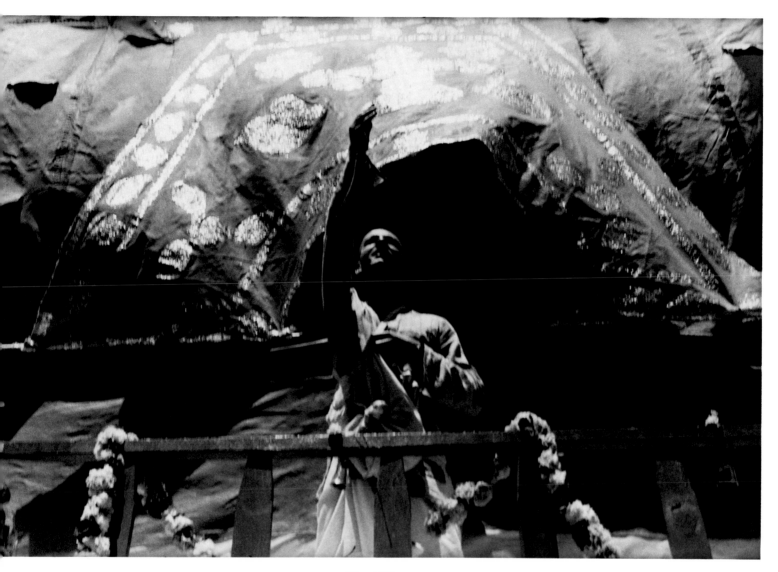

Wes Miller

Naomi Bushman

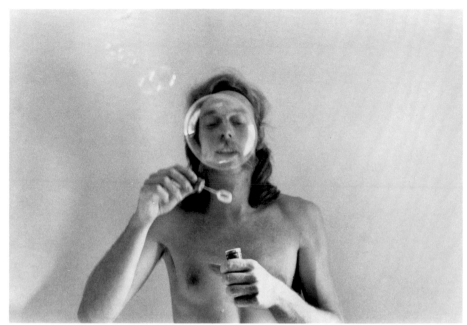

Dan McCormack

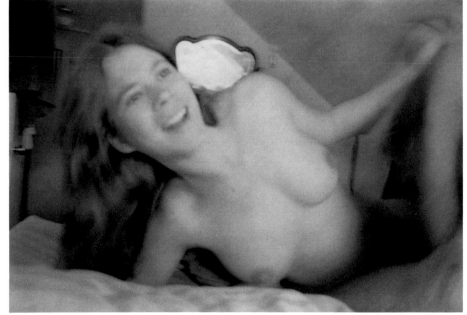

John Loori

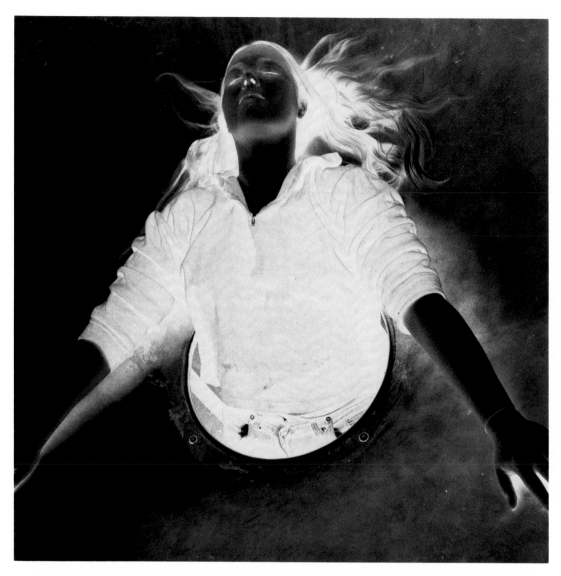

Cameron Sesto

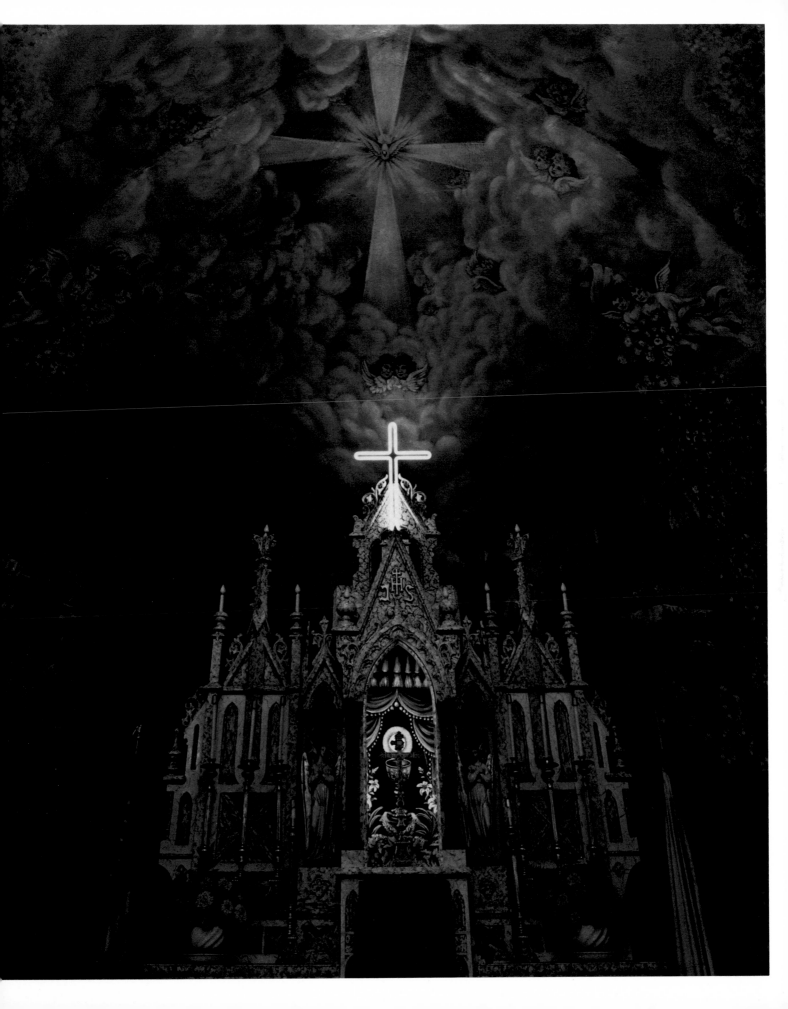

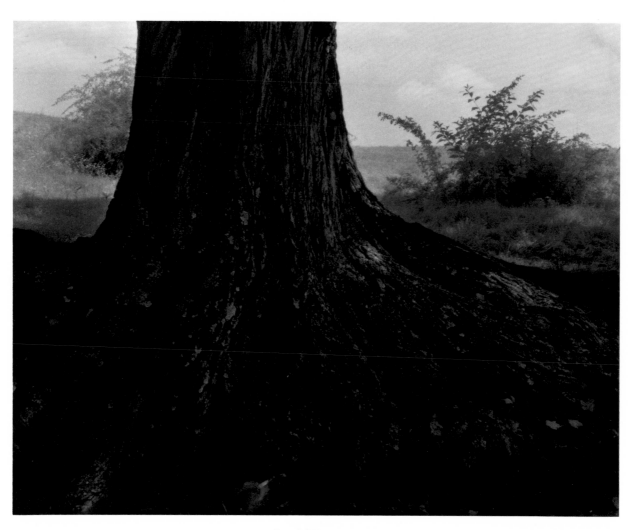

Arnold Kramer